INSTRUCTIONS

Many writers will tell you that it's important get "in the zone" to write. Taking this to he for how to get in the right mood to start wi

- Put down this book, have a dance party, pick up this book, and open it.
- Tilt your head back, laugh maniacally, pick up this book, and open it.
- Silently raise your fist into the air; pause for a moment, lower your fist, pick up this book, and open it.
- Put this book down on the floor, walk to the other side of the room, frolic back to where this book is, pick up this book, and open it.
- Find a quiet space, sit comfortably, open your mouth, joyfully shout a steady stream of nonsense words, pick up this book, and open it.

Every page of this book was made for writing, drawing, coloring, and making a mess. You'll need a pen or pencil and whatever coloring implements you like best; otherwise, you've already got everything you'll need!

Carpe weird!

Kate
The strange creature who made this book

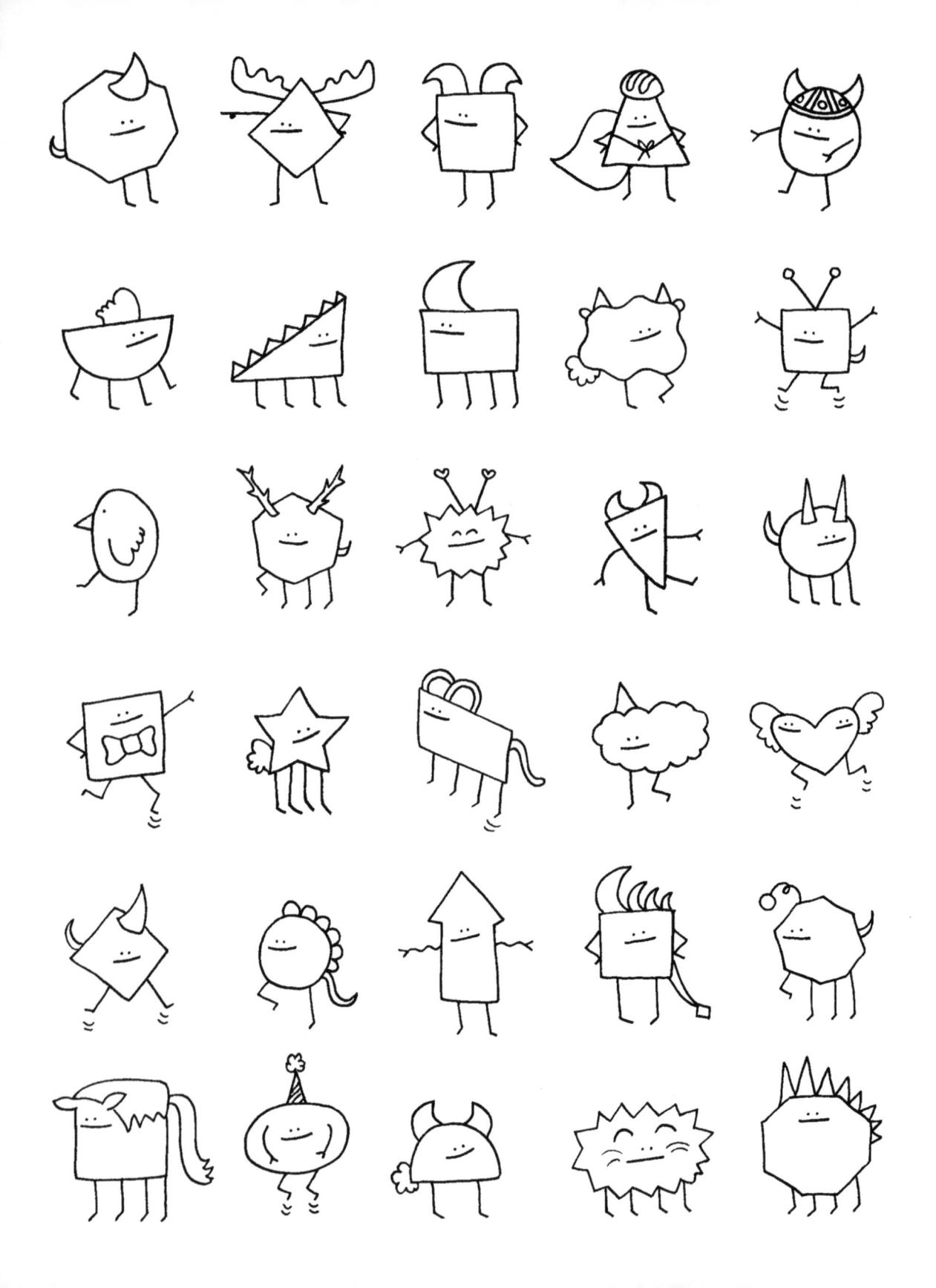

A Creative Journal for Misfits, Oddballs, and Anyone Else Who's Uniquely Awesome

Kate Peterson

A TarcherPerigee Book

An imprint of Penguin Random House LLC 375 Hudson Street New York, New York 10019

Copyright © 2017 by Kate Peterson

Penguin supports copyright. Copyright fuels creativity, encourages diverse voices, promotes free speech, and creates a vibrant culture. Thank you for buying an authorized edition of this book and for complying with copyright laws by not reproducing, scanning, or distributing any part of it in any form without permission. You are supporting writers and allowing Penguin to continue to publish books for every reader.

Tarcher and Perigee are registered trademarks, and the colophon is a trademark of Penguin Random House LLC.

Most TarcherPerigee books are available at special quantity discounts for bulk purchase for sales promotions, premiums, fund-raising, and educational needs. Special books or book excerpts also can be created to fit specific needs. For details, write: SpecialMarkets@penguinrandomhouse.com.

ISBN 9780143130895

Printed in the United States of America 3 5 7 9 10 8 6 4 2

FOR NATE, my mutual weirdo

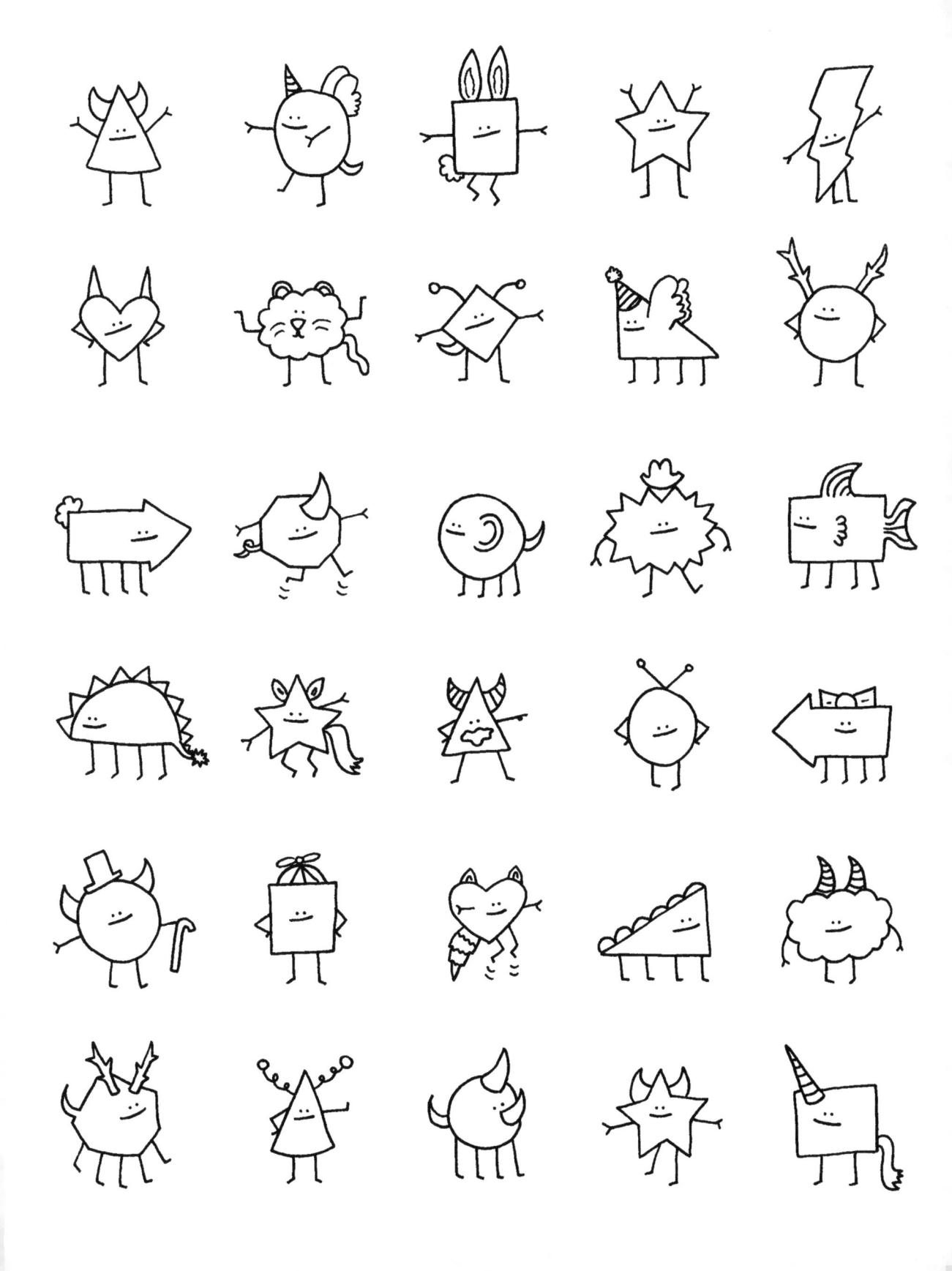

TWENTY QUESTIONS ABOUT Name: Nicknames: Family members: Closest friends: Current job title: Places lived: Favorite places visited: Current city: Favorite local hangouts: Favorite things to do:

OWNS THIS Things done every day: Favorite books: Favorite movies: Favorite bands: Favorite foods: Most prized possessions: Areas of expertise:

Talents and skills:

Proudest accomplishments:

Biggest goals:

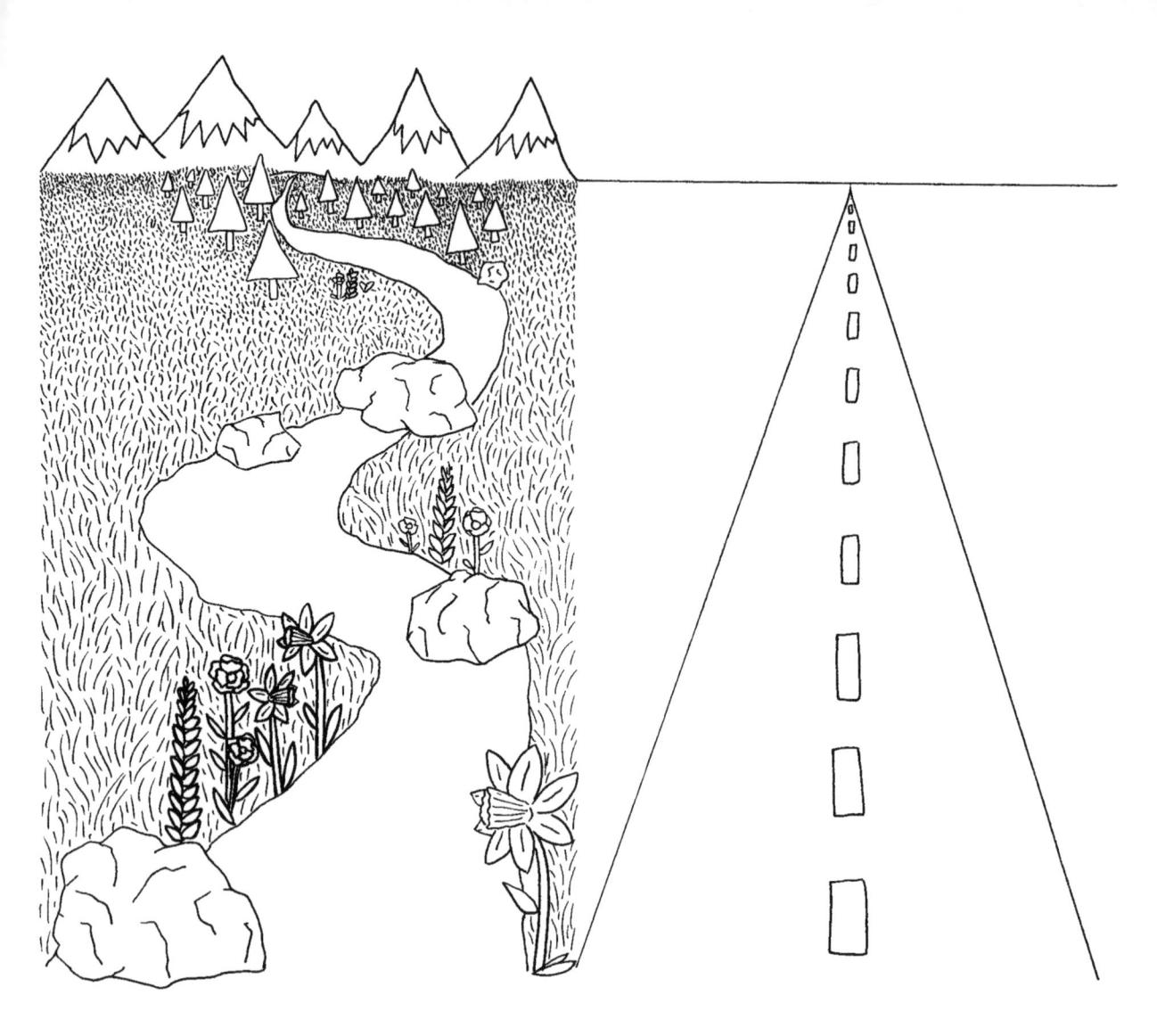

"NORMALITY IS A PAVED ROAD.

IT'S COMFORTABLE TO WALK,

BUT NO FLOWERS GROW ON IT."

- Vincent van Gogh

HERE'S WHAT'S UNIQUE ABOUT ...

My home:

My family:

The way I was raised:

The country I live in:

The state I live in:

The city I live in:

My career:

How I got to where I am today:

My appearance:

My friends:

My sense of style:

The way I see the world:

OF OWERE A...

Based on your personality and characteristics, what kind of each of these categories would you be?

Write about someone you know who stands out from the crowd. What do you admire about them? What do you think it's like to be in their skin?

いこい

1

11/2

BUILD YOUR OWN SPIRIT ANIMAL

Your spirit animal is the animal who best represents your characteristics and personality; but, being the weirdos we are, why limit ourselves to animals that already exist? Combine these animal building blocks or create your own from scratch to capture your particular brand of peculiarity.

100. 0	001011011	10 00071010	7001 Part	10010(1 01 0(1)	o or pec	511 W1 11 7 .
horns & antlers:						tails:
(m_~)						B
Wille						The state of the s
00						0
A						<u></u>
The state of the s						\Im
M m						\approx
						ears:
noses:						(0)
\odot						
11						\mathbb{C}^{2}
= 9 =						?
		<u> </u>	eet:			G 7
) [4.1	4	(0-0)
	, •			-000		

RANDOM ACTS OF WEIRDNESS -CHALLENGE

LEVEL 1

- □ Have a dance party all by yourself.
- □ Wear some seriously funky socks.
- □ Make a mess on purpose.
- □ Use chalk to write a quote about weirdness on a high-traffic sidewalk.
- □ Write silly jokes on postcards and send them to your friends.

#randomactsofweirdnesschallenge

MAJORITY REPORT

When do you fly solo and when do find yourself in a crowd? Fill in the blanks to see where you find yourself in good company and where you stand alone.

Some people	, bu
While most people never	,
Like most other people, I	
I hate being the only one who	
I love being the only one who	
I strongly agree with the popular belief that _	
I strongly disagree with the popular belief that	
D % D % D % Q	D %

YOUR MISSION, SHOULD YOU CHOOSE TO ACCEPT IT What's your mission for this weird and wonderful life?

1 0		1	7 0	D		1		3			0 0]	
	Ø	۵		Q	۵		Q	0			Ø	۵		
0 0		t wer ing u	re you p?	taug	ht	about	ind	ividu	ualit ₎	/ a.s	s λ ₀	U WE	re	
0														
														0
а П														0 0
														7 0 0
														۵
0														П
0 0 0														0 0 0
0														
														۵ ۵
0 0	п О	۵	a	Ø	۵	П	Ø	c			O	۵		
	ı <u> </u>			<u> </u>	7 0		ū		0 0			0 0		o 0

BE THE STRANGE YOU WISH OF TO SEE IN THE WORLD

Fill this page with the weirdness you want to be, see, and set free!

BIZARRE TRENDS FROM THE WEIRD DECADE I GREW UP IN

MY FAMILY'S WEIRPEST TRAPITIONS

All normal families are alike; each weird family is weird in its own way.

MY WEIRD HOMETOWN

Every seemingly normal town has a hidden layer of quirkiness.

What makes the town you grew up in weird?

	w
	CB 4
· · · · · · · · · · · · · · · · · · ·	3 C
Which of your weird qualities did you inherit, and which ones did you learn?	## C
which ones did you learn?	C 4
3 · CB	
\mathcal{C}_{3}	₩ ₩
₩ 3 ₩	
₩ ₩	CB 4
₩ 3 ₩	## C
ඟ }	
₩ 3 ₩	## C
₩ ₩	CC 4
, ₩ 3 · ₩	
	€3 C
## ## ## ## ## ## ## ## ## ## ## ## ##	(C)
	C
3 · ₩	
₩ 3 ₩	C 3 C
3 HB HB HB HB HB HB HB HB HB	is Ci
we are up we are we we	4

THE WEIRDEST THINGS I DID WHEN I WAS A KID

No judgment. (Just suppressed giggles.)

Draw an apple that will fall reeeeeally far from the tree.

AN OPPBALL IS BORN

What were the most pivotal events, conversations, and situations that shaped you into the strange creature you are now?

What kind of role model did you need when you were younger? + + + How can you be that role model for someone else?

IT TAKES A VILLAGE TO RAISE A WEIRDO

Who were the most influential figures in your village?

HOW PO YOU THINK YOU'D BE DESCRIBED BY ... your best friend your first grade teacher your dad your mom your biggest rival your grandparents someone you just met your boss

A A * * \forall A Think back to a moment when you felt out of place as a child. What would you tell your younger \Diamond self now? \bigstar × A * * * \Diamond × A A \triangle × A \Diamond × ×

5 WORDS TO PESCRIBE MYSELF AT AGE...

Once you get past the present, choose 5 words that describe what you hope you'll be like at that age. (Spoiler alert: weirdness and awesomeness ahead.)

5:

10:

15:

20:

25:

30:

40:

50:

60:

70:

80:

90:

Do you think you FIND yourself as you grow older, or CREATE yourself as you grow older?

"IT'S WEIRD IT TO BE WEIRD.

- JOHN LENNON

Black sheep welcome here! Add a few oddballs to this flock.

1

mM

FAVORITE WEIRDOS

FROM BOOKS

(Fictional or real!)

What makes them weird? Why is their weirdness awesome? Name

I THINK YOU'RE WEIRD. LET'S BE FRIENDS.

Fill in the speech bubbles with compliments. Human points achieved!

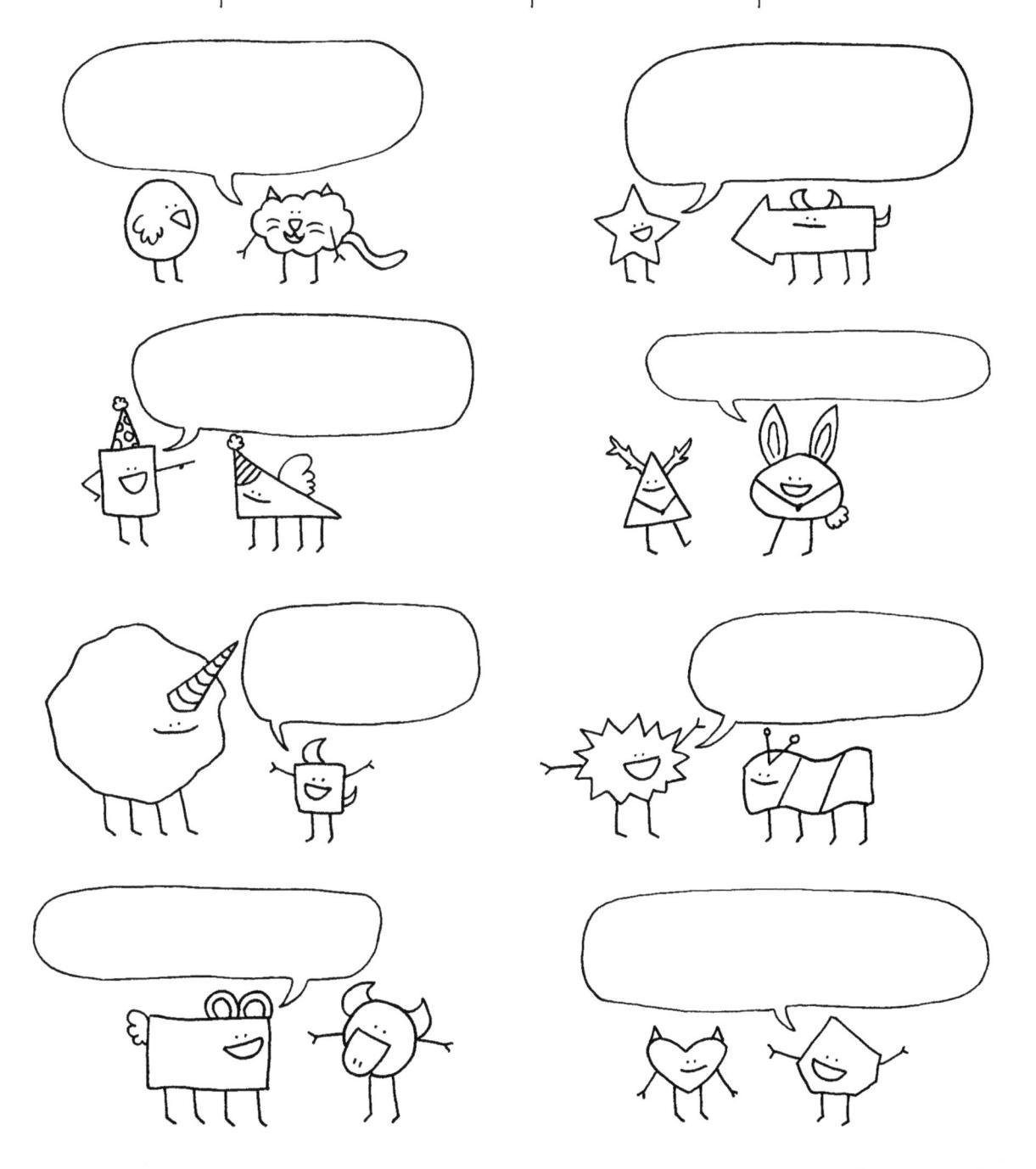

AND THE AWARD GOES TO ...

☆

The weirdest thing I've ever eaten:

The weirdest place I've ever been to:

The weirdest conversation I've ever had:

The weirdest date I've ever been on:

The weirdest thing I've ever seen in a public place:

The weirdest thing I've ever done in a public place:

The weirdest movie I've ever seen:

The weirdest book I've ever read:

(Think of this as your personal Guinness Book of Weirdness Records.)

The weirdest piece of clothing I've ever worn:

The weirdest idea I've ever had:

A

X

X

 \bigstar

A

X

 \bigstar

A

X

X

 \bigstar

A

X

* The weirdest thing I've ever said out loud:

The weirdest thing I've ever seen in a big city:

The weirdest thing I've ever seen in the great outdoors:

The weirdest thing I've ever done with my friends:

* * The weirdest thing I've ever done with my family:

The weirdest thing I've ever done while alone:

器 松 公 松 器 松 松 松 经 松 松 公 松 松 松 公 公 松 W. 袋 *** 袋 袋 袋 ₩ 松 ₩ 7 公 公 Pick one of your favorite unique attributes. *** **%** 公 What would your life be like without it? ** 玅 ES 3 公 公 松 袋 袋 2 松 公 £ 3 **₩** 袋 翌 *****3 EG 松 公 袋 從 公 松 袋 ZZZ *** **\$**3 玅 ES 经 松 公 袋 袋 松 松 *** 從 ** ** *****3 \$\$ 松 经 袋 袋 公 公 25 袋 ** 玅 \$ ☆ 松 经 公 公 松 松 公

Leader, follower, or Introvert, extrovert, or Adventure, caution, or

7.20 640 +	Adventure, caution, or
EL SAS A	Glass half full, half empty, or
* 4 ° D°	Truth, dare, or
4 5 to 2 to 3	Lover, fighter, or
9,0	Messy, neat, or
100	Spontaneous, planned, or
****	City, country, or
\$ °\$\frac{1}{2} \	Cats, dogs, or
	Hot, cold, or
42+83	Car, plane, or
+000	Walk, run, or
A 25 A	Books, movies, or
00000	Fiction, non-fiction, or
# 0.0	Morning, night, or
1 + 1 T	Winter, summer, or
~ £	Spring, fall, or
1 D A	Spring, tall, or
) ~ ~ ~ ~	Sun, moon, or
00 00 1 22	Oceans, mountains, or

Trees, flowers, or

SOMETHING WER
Call, text, or
Teacher, student, or
Pen, pencil, or
Crossword, sudoku, or
Black, white, or
Classic, modern, or
Detailed, abstract, or
New, vintage, or
Salty, sweet, or
Chocolate, vanilla, or
Scrambled, fried, or
Spicy, mild, or
Cake, pie, or
Peanut butter, jelly, or
Burgers, hot dogs, or
Ketchup, mustard, or
Salt, pepper, or

Pancakes, waffles, or ____

Coffee, tea, or ____

Beer, wine, or _____

Shaken, stirred, or

	455 1	A 7
-	* 54 77	2 N
_	20.14	5
-	7,+, 4, 0, 0, 0, 0, 0, 0, 0, 0, 0, 0, 0, 0, 0,	7
-	E a c	9
_	4 × 3	0
_	100 P	٠, ۲.
_	MXE	₹
_	0+170-7	
_	14 13	5
_	A. 77	7
_	Emy 1 8	D

- Matthew Goldfinger

MY FAVORITE WEIRD WORDS

bubble snarf duene conundrum * hobgoblin * anemone * fustigate * hamfisted * slaphappy * syzygy * chortle * guffaw shenani gans balderdash * oaf * hubbub tchotchke * purlique * mugwump * pumpernickel * strumpet * cattywampus yodel gumbo * mooch * hullabaloo * brouhaha * bombastic jamboree * blubber * curmudgeon * gibberish

honeyfuggle * collywobbles * argle-bargle * blatherskite * chanticleer * gazebo pouch * persnickety * rhubarb * kerfuffle * quixotic * bamboozle * quip * quidnunc

DRAW YOUR WEIRD DREAM HOUSE

A spiral slide instead of a spiral staircase? Check. A castle turret full of books and wine? Yes please. An oven with the capacity to cook twenty pizzas simultaneously? Nailed it.

MY WEIRD STUFF

What are the weirdest objects you own? Bonus points for odd thrift store finds, handmade heirlooms, and funky old furniture. (Deduct points for any and all clown figurines.)

gnomes

terrifying nutcrackers

WEIRDOS INVITED

Make a list of odd theme parties to throw. BYOWeirdness!

Make faces on this page! If you use pen, they'll get stuck that way. WHEN IN DOUBT, MAKE FUNNY FACES." - Amy Poehler

PEOPLE IT'S EASY TO BE MYSELF AROUND

Birds of a freakish feather flock together.

How do you share your weirdness on social media?

DRAW A WEIRD SELFIE

(Bonus points for posting it with #myweirdselfie!)

PECORATE THESE HATS AS STRANGELY AND SPECTACULARLY AS YOU CAN

GIVE YOURSELF STAGE NAMES

Because alter ids are way better than alter egos.

Rock star:

Literary pen name:

Movie star:

Rapper:

Pirate:

Wrestler:

Drag queen:

Country star:

Superhero:

Supervillain:

FAVORITE WEIRDOS FROM MOVIES

(Fictional or real!)

Name	What	makes	them	weird?	Why	is their	weirdness	awesome?
1								

THE MOVIE OF YOUR LIFE

Who plays you?

Who are your costars?

Is there a villain?

Where will it be filmed?

What shocking plot twists occur?

What pivotal scene will win the lead actor an Oscar?

What's on the blooper reel?

What does the poster look like?

1000	$\Delta \Delta \Delta \Delta \Delta$	$\Delta \Delta \Delta \Delta$	$\wedge \wedge \wedge \wedge$	$\wedge \wedge$	$\wedge \wedge \wedge$	$\wedge \wedge \wedge$	$\triangle \triangle \triangle$	$\Delta \Delta \Delta \Delta \Delta C$				00000	
			what best									00000	0000
100				~~									ÖÖÖ
100	Who	and	what	br	inas	out	the	best	in	you,	and	what	000
100	1	11	1 1		J	1 1	1.1	7		1			000
100	does	the	best	in	you	look	like						000
100					,								000
100													000
100													000
100													000
													000
100													000
100													000
ìÒÒ													000
													ŏŏŏ
IÕÕ													000
100													000
100													000
100													000
100													000
100													0000
													000
100													000
100													000
100													ŏŏŏ
iõõ													000
100													000
100													000
100													000
													000
) 0 0													000
000													000
100													000
100												*	000
100													000
100													000
100													ŏŏŏ
100													ŏŏŏ
100													000
100													000
												00000	
1000	$1 \cap \cap \cap$	$\cap \cap \cap$	$\triangle \triangle \triangle \triangle$	$1 \cap \cap$	$1 \cap \cap \cap$	$1 \cap \cap \cap$	$1 \cap \cap \cap$		Ω	\mathcal{L}	1000	ነሰሰሰሰ	

RANDOM ACTS OF WERDNESS E CHALLENGE

LEVEL 2

□ Order dessert first.

- □ Make up a word and try to slip it into three different conversations without anyone noticing.
- □ Have a conversation in an accent you don't actually have.
- □ Give a goofy fake name when you order coffee.
- □ Write haikus about different foods on sticky notes, go to the grocery store, and leave them on or near those foods in the store.

#randomactsofweirdnesschallenge

PRAW A SELF-PORTRAIT WITH YOUR NON-POMINANT HAND

(Because who wants to take themselves too seriously, anyway?)

HERE'S MY HEART.

Of all the things that make up this weird world we live in, what do you care about most in that odd little heart of yours? Label each section with something you hold dear.

What do you think about in that peculiar brain you've got inside your head? Label each section below with the things you find yourself thinking about the most.

THOUGHTS THAT ENTERED YOUR HEAD TODAY

THINGS I'VE THOUGHT ABOUT THAT MOST OTHER PEOPLE HAVE PROBABLY NEVER THOUGHT ABOUT

What did Yankee Doodle call macaroni? His pony? His hat? His feather? #manofmystery

THESE PAGES ARE FOR POOPLING AND MARVELING AT

ALL THE THINGS THAT COME OUT OF YOUR BRAIN

despite the circumstances. How did it feel at the time,

Think back to a time when you were true to yourself

and how do you feel looking back on it now?

< x x K X X

(XX

K X X K X X

< X X < × × K X X

< × ×

< x x < × ×

K X X

KXX

KXX

K X X < x x

KXX

K X X < × ×

K X X K X X K X X

K X X < × × K X X

< × ×

K X X

KXX K X X KXX

K X X K X X K X X

K X X

K X X K X X

K X X

KXX

K X X K X X

K X X K X X

K X X K X X

KXX K X X KXX

KXX K X X

K X X KXX

K X X

K X X K X X K X X

K X X

K X X

KXX

KXX K X X

K X X

K X X K X X

K X X K X X

K X X

K X X K X X XXX

K X X

XXX

K X X

XXX X X X XXX

XXX

xxxxxx

××××××

XXXXXX

××××××

×××××

XXXXXX

XXXXXX

××××××

××××××

×××××

XXXXXX ××××××

×××××× ××××××

××××××

××××××

XXXXXX ×××××

××××××

××××××

××××××

××××××

××××××

×××××× ××××××

××××××

××××××

XXXXXX ××××××

XXXXXX XXXXXX

×××××

××××××

××××××

××××××

XXXXXX

××××××

××××××

×××××

XXXXXX

XXXXXX

××××××

×××××× XXXXXX

××××××

××××××

××××××

XXXXXX

××××××

XXXXXX

XXX ××× ×××

XXX

XXX

XXX

XXX

KXX

XXX

XXXXX

XXXXXX

XXXXX XXXXX

(XXXXX

XXXXX

XXXXXX

XXXXX

:xxxxx

CXXXXX

:xxxxx

(XXXXX

XXXXX

XXXXXX

KXXXXX XXXXXX

KXXXXX

KXXXXX

XXXXX

XXXXX

XXXXXX

XXXXXX

XXXXX

XXXXX

XXXXXX

XXXXX

YOUR WEIRD COAT OF ARMS

Draw and color four things you choose to represent your odd self in the spaces on the shield. Share your weirdness with #myweirdcoatofarms!

\$\frac{1}{2}\frac{1}{2

QUOTES THAT SPEAK TO ME

"Whatever makes you weird is probably your greatest asset."
- Joss Whedon

 FILL THESE PAGES WITH QUOTES THAT STRIKE A CHORD IN THE WEIRD KEY OF YOUR LIFE

"There is no exquisite beauty...without some strangeness in the proportion."

PRAW A CRAZY PREAM YOU'VE HAP...

...AND NOW DRAW A CRAZY DREAM YOU'D LIKE TO HAVE

SONG LYRICS ABOUT BEING A STRANGE CREATURE

What lyrics make you want to march to the beat of your own drum?

:0(-0 ;\o`; What, if anything, prevents you from being your authentic self? :0: :0: ÷0. ÷0.

BUILD YOUR OWN MOTTO

Underline the words that speak to you. Then, fill your favorites into the blanks on the opposite page to create your own quirky motto, or go rogue and come up with your own from scratch.

NOUNS:

greatness, laughter, power, creativity, intelligence, fun, joy, happiness, travel, pizza, shenanigans, hootenanny, coffee, attitude, peace, world, nature, adventure, burrito, voyage, expedition, exploration, imagination, thought, caffeine, sandwich, unicorn, beauty, uniqueness, home, weirdness, dreams, magic, change, wonder, pride, discipline, friendship, family, home, cats, dogs, music, party, coffee, honesty, diversity, strength, ambition, food, personality, energy, love, brilliance, knowledge

VERBS:

seize, create, make, find, conquer, work, play, believe, think, go, move, run, rock, explore, build, write, draw, capture, plant, adore, imagine, think, forge, be, mind, try, get, shine, care, dance, sing, take, achieve, win, choose, fill, exercise, push, celebrate, laugh, talk, walk, stay, call, add, adapt, simplify, give, collect, discover, help, guide, pioneer, succeed, paint, boogie, skip, leap, invent, grab, open, read, smile, cook, pursue, listen, shout, love, cultivate, grow, frolic, giggle

"		_ the	<i>"</i>	
<u> </u>	ever	y day with		<i>"</i>
"There can be no		without _		<i>"</i>
"Find		in the		
	the	you wish	to see in	the world
"Say	yes to		<i>"</i>	
"Dance to the		of your own _		<i>"</i>
"	s aren't	born, they're		<i>"</i>
w	it with		_ or not a	t all"
w		,		<i>"</i>

OR WRITE YOUR OWN FROM SCRATCH:

MAKE A MOTTO COLLAGE

Write your shiny new motto on this page and fill it with clippings of words, photos, and whatever else represents your new words to live by.

Fill this page with all the strange and lovely things you give the most hoots about.

*** *** 44. *** *** I am happiest in my own skin when... 44. 4 4 44. 4 4 44. *** *** 44-*** *** 44. *** *** 4 4 -* * 44. * * 44. * * 44. ☆ ☆ 4 4 -4 4 4 4 -*** * * * * *** 44. *** *** 44. * * 444 4 4 44. *** *** 44. 4 4 44 4 4 *** * * * *** 4 4 4 4 *** * *** 4 4 *** * * *** \$ \$ · *** *** 44 *** *** 44 4 4 4 4 4 4 4 4 4 4 44 4 4 44 4 4 4 4 4 4 4 4 *** *** 4 4 4 4 4 4 *** *** 4 4 **☆ ☆ * *** * * *** ***

· \$ \$ ❖ \$ \$ \$ \$ \$ \$ * - * * * * * * * * * * * * * * ❖ * * * * ❖ * * * * ❖ · * * * * **→** ‡ ❖ * **→** ‡ ❖ * → * * ❖ **→** ☆ ❖ * **→** ☆ * * · * ❖ * → ☆ * ❖ - \$ \$ * * · * * * * · \$ \$ * * · \$ * ❖ * · * * ❖ * →→ ❖ * · * * ❖ * - * * ❖ * → ☆ ❖ ❖ * · * * ❖ * · * ✡ * · * * ❖ * · * * ❖ * - **☆** ❖ * * · * * ❖ ❖ · * * ❖ ❖ · 🌣 * ❖ * · * * * * · 🌣 * * ❖ * * * ❖ ❖ · * * * * · * ❖ * * * * ٠ * * * * * * * * * * * ❖ ❖ ❖ kind a * ❖ * * ❖ * ѷ \$ \$ · * * * * * * * *

THINGS TO BE GRATEFUL FOR IN MY WEIRD, MESSY, AWESOME LIFE

Fill this page with all the things that make you feel like the luckiest living soul in all the land.

DRAW YOUR FREAK FLAG

Ever heard the phrase "let your freak flag fly"? Well, now's your chance, you magnificent unique snowflake.

What are you freaky-good at?

imitating animal calls

opening

jars

at rock, paper,

scissors

making perfectly pancakes

knots

distances

How do you turn things around when you're feeling down on yourself?

It's not easy being a sardine.

RANDOM THINGS THAT MAKE ME SMILE

socks

Δ

foods

miniature

GIVE THESE HEADS SOME SERIOUSLY WEIRD HAIRSTYLES

Little girls can be made of whatever they want. Shut it down.

A man's home is his castle.

An apple a day keeps the doctor away.

Better safe than sorry.

Cleanliness is next to godliness.

Curiosity killed the cat.

Diligence is the mother of good fortune.

Nothing is certain but death and taxes.

Opportunity seldom knocks twice.

Sugar and spice and everything nice; that's what little girls are made of.

The grass is always greener on the other side of the fence.

You can't have your cake and eat it too.

FAVORITE WEIRDOS

Name What makes them weird? Why is their weirdness awesome?

0 DD * 口 00

DRAW A MAP OF YOUR COMFORT ZONE

That first step is a doozy, but the journey of a thousand miles starts with a little pep.

. Sit in a park, coffee shop, or other public place and make note of the little oddities you see around you.

THE WEIRDEST THINGS I'VE OVERHEARD IN PUBLIC

(Pro tip: subways and buses, twenty-four-hour diners, and tiny towns are gold mines for weirdness.)

FORTUNE FAVORS THE WEIRD

What ridiculous message would you want to find inside a fortune cookie? What would you want to tell someone else in theirs?

الساد		LJUL	<u> </u>		1	_10		LJU			1000		LJUL
ПП									ПГ	$\neg \Box$			
UU	1 11			四川			ПП			П	냄		UOUL
30			品		引品				7	금		吕	
習							1		1		1	1	
		What	are	the	rule of	Whi	ch n	ne c	40	VOL	want	+0	
Π		WW FICH	WIL	1110	i uics.	V V / 1 1	CH U	1100	UU	you	WWIII	10	
	1 11									•			ПППП
		break	(
		0.0011	•										
習													1
7													
111													
44	\Box U												几日二
= 1													
-77													
当													100
ПП													
	1 17												77
-													UBP
70	口口												поп
БU													
ПП													
	1 11												7011
	브는												
品													
"													
44													
7													
=11													
пП	ПП												
\square	1 17												77
													Ubi
7	밂												ППП
EL													
	1 11												매님
700													
習品	1 17												
44													매님
7-													
EL!	品												
品								1 0	25				
Inm		MILL		MILL		MILL			ПГ		MILL		MILL
	1 17	ااامن		االمت		االمت		77			الاقت		الاقت
		매브		먭씯		릅쁜			-		마님		매님
7	므므	ПОГ	디므	ППП	一二二	ПОТ	识品	ПС		吕吕	ПОП	므므	ПОП
					0.000		-						

CONSTELLATIONS

MY WEIRD BUCKET LIST:

twenty strange things to do before I die

ijij. 1.

2. 12.

3. 13.

j4.

15. 5.

16.

17.

18. 8.

19. 9.

10.

20.

GIVE THIS PEACOCK THE CRAZIEST TAIL YOU CAN IMAGINE 4

FREAK OF NATURE

Fill this page with things you see that prove Mother Nature's a weirdo too.

numbat స్ట tapir (స్ట స్ట స్ట leafy స్ట seadragon ద్ది ద్ద ద్ది దొ ద్ద shrew స్ట ద్ద స్ట MY FAVORITE WEIRD ANIMALS ద్ద దో ద్ద ద్ద ద్ద kinkajou okapi ద్ద ద్ది ద్ద దో ద్ది స్ట స్ట pangolin స్ట

BIZARRE FACTS I'VE LEARNED ABOUT THE WORLD

Ooh, baby, it's a weird world.

have so many friends.

FACT: there are over 1 million ants for every person on the planet.

Aye! Sold of the second of the

FACT: Scotland's national animal is the unicorn.

FACT: light doesn't always travel at the speed of light.

EXPERT-LEVEL WEIRD

Pick something in this weird world you've always wanted to know more about and become an expert on it!

Topic:

Facts you've learned about it:

How can you use your awesome new knowledge?

E WORLD HOLIDAYS WE'D ALL CELEBRATE IF I WAS IN CHARGE

Take Your Sweatpants to Work Day

Breakfast for: Dinner Day

International Movie Marathon Day

Congratulations! You've just been put in charge of a new country. How will you rule over your dominion? Name of country: Your title as leader: National anthem title: Most important national holiday: Customary greeting: National dish: National animal: Poet laureate: National sport: Rights granted to all citizens:

FAVORTE WERDOS

FROM HISTORY

Name What makes them weird? Why is their weirdness awesome?

THE CRAZIEST THING I'VE

Love:

Friendship:

Family:

Work:

School:

Money:

My health:

The heck of it:

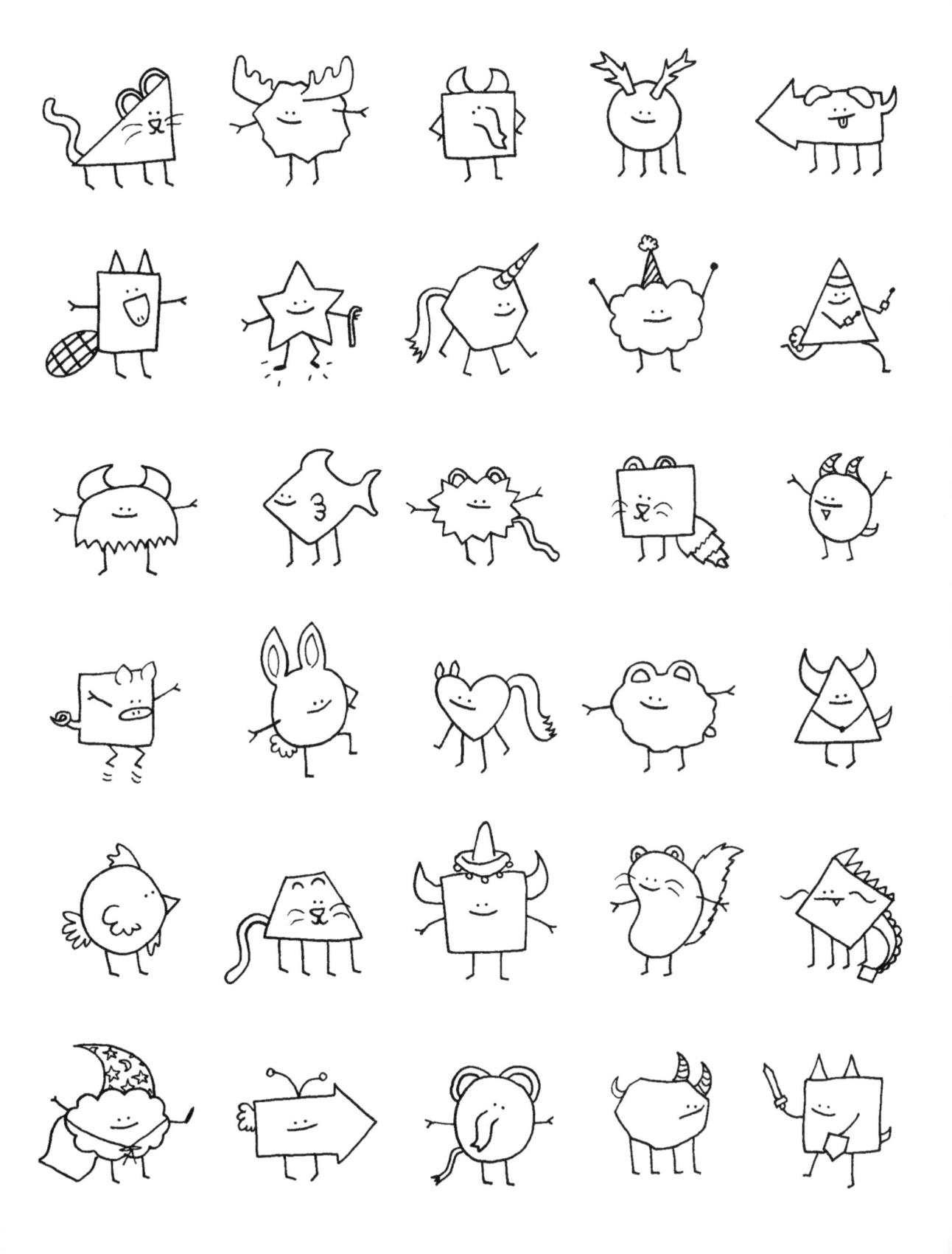

PERMISSION SLIPS, FROM YOU TO YOU

is hereby grants permission to sing in the showe and/or car as loud as she or l likes, and without regard to th artistic merit or popularity of th songs chosen, from this day forward Signed:	granted permission to be as he peculiar, quirky, strange, wacky, and weird as he or
is hereby granted permission to wear whatever odd pieces of fabric strike his or her fancy, which shall include cases where said outfit brings him or her joy while evoking the disapproval of	is hereby granted permission to be curious and excited and knowledgeable about whatever aspects of the world he or she wishes to get super nerdy about, and is granted permission

_ is hereby granted permission to feel awesome about her or himself. No questions asked. No judgment passed. Signed:

others, especially parental units,

and shall also encompass

emergencies created by

shortages of clean laundry.

Signed:

about, and is granted permission

to be as unapologetically

enthusiastic about said topics as

he or she desires. Signed:

granted permission to	granted permission to
from this day forward. Signed:	from this day forward. Signed:
granted permission to	granted permission to
from this day forward. Signed:	from this day forward. Signed:

THE MOST OFF-THE-BEATEN-PATH PLACES I WANT TO VISIT

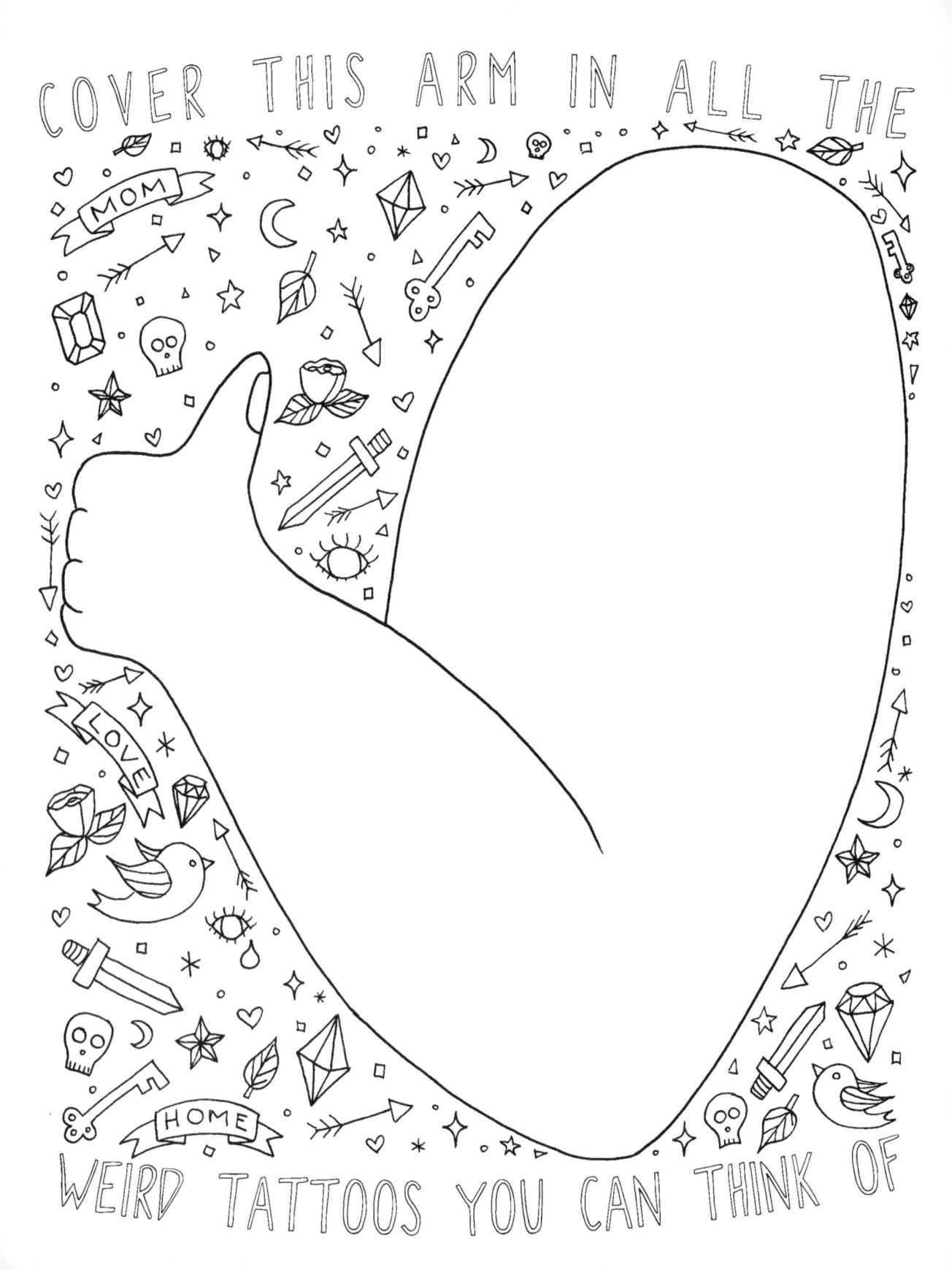

RANDOM ACTS OF WERDNESS OF CHALLENGE

LEVEL 3

- □ Dance in any public setting where you are the only one dancing.
- □ Eat a hot dog with chopsticks.
- □ Go to a thrift store with a friend. Pick out ridiculous outfits for each other, and then wear them in public for the rest of the day.
- □ Sing karaoke to a song you've never heard before.
- □ Bake a cake, frost it, and immediately plunge your face right into the top.

#randomactsofweirdnesschallenge

How can you encourage weirdness in others? b [V Did you know our bodies are composed of 90% awesomeness? 0 0 7 0 0 7 0 0 7 D 00

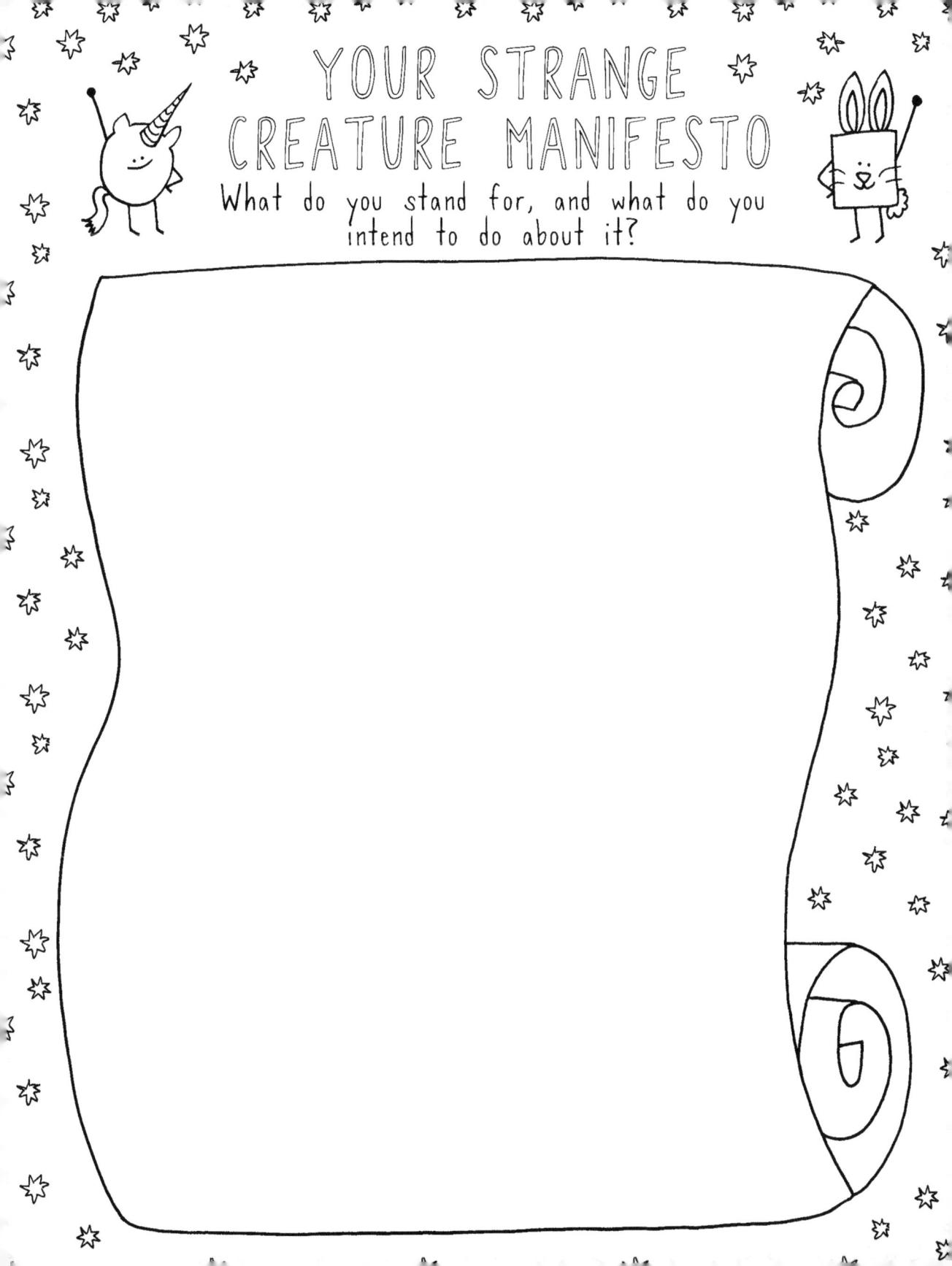

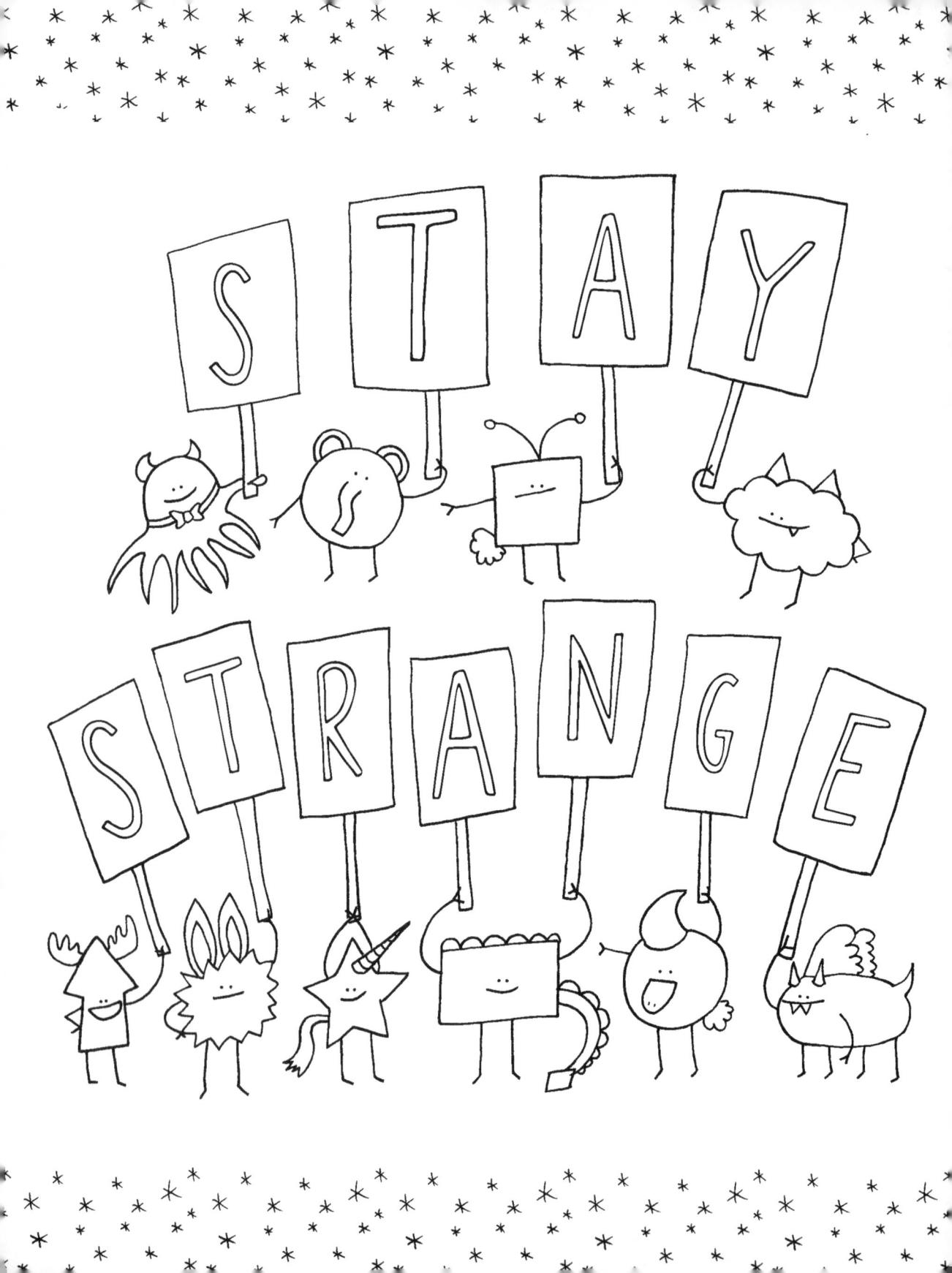

ACKNOWLEDGMENTS

One day, while working at the day job I had at the time, I got an email out of the blue that would change my life forever. That email was from Marian Lizzi, my future editor; and I will forever be grateful to Marian for taking a chance on me, for championing weirdness with me, and for her expert guidance. I would also like to thank assistant editor Lauren Appleton, and everyone at Penguin Random House and TarcherPerigee for their help in making this ridiculous thing come to life. Thank you!

Enormous thanks to Rachel Beckwith of R Beckwith Design in Portland, Oregon, for her time and expertise in helping me digitize the handwritten typefaces for this book. Hooray Rachel!

Thanks to my parents for raising a total weirdo and encouraging her in all her weird endeavors (and mailing her a giant pile of chocolate at the eleventh hour!).

Thank you to my husband, Nate, for keeping me sane during this process in all the right ways (food, laundry, clean-ish house) and insane in all the right ways too (dance parties, late-night punch-drunk laughs, general mayhem). My weird world revolves around you!

Finally, to all of you who have cheered me on, and cheered on the things I draw, and cheered on my illustration business, The Dapper Jackalope: I can't thank you enough. I still can't believe I get to do this for a living and I'm grateful for it and all of you every day. Thank you!

ABOUT THE AUTHOR

Photo by Toni Osmundson

Kate Peterson is an illustrator in Boise, Idaho. She likes drawing monsters and making art that gets people of all ages thinking like kids again.

For more of Kate's work, follow:

@thedapperjackalope

www.thedapperjackalope.com